The National Portrait Gallery

The National Portrait Gallery was founded in 1856 to collect the likenesses of famous British men and women. Today the collection is the most comprehensive of its kind in the world, and constitutes a unique record of the men and women who created (and are still creating) the history and culture of the nation. The Gallery houses a primary collection of over nine thousand works, as well as an immense archive. There is no restriction on medium – there are oil paintings, watercolours, drawings, miniatures, sculpture, caricatures, silhouettes and photographs. The Gallery continues to develop its role through its constantly changing displays, its growing programme of international exhibitions, its acquisitions and commissions, and the annual portrait competition for young artists.

D1188600

Portraiture in the 20th century

The momentous events, the revolutionary social and economic changes, and the extraordinary pace of advances in science and technology which can be seen to characterize the history of the 20th century, are seldom reflected in the art of portraiture. When we think of the great people of our age, Churchill, Einstein or Kennedy, it is invariably a photographic

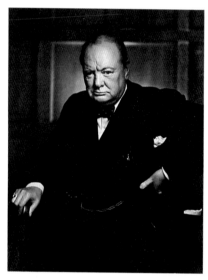

image which comes to mind. Whether a much-reproduced 'studio' photograph like the Canadian photographer Karsh's famous 1941 study of Winston Churchill, or a visual compendium derived from innumerable news films and press photographs, the immediacy and accuracy of the photographic image has superseded the art and craft of the subjective interpretation of the painter or sculptor. Ever since the invention of the photograph in the mid-19th century, prophets have been proclaiming the death of painting, and there is no doubt that competition from photography has seriously undermined not only the need for representational painting but also the desire of the artist to produce creative work in a genre which has apparently outlived its usefulness. In earlier ages, portraits of reigning monarchs or religious leaders were essential for purposes of state and propaganda, and could be distributed by means of copies and engravings, but most people would have had little idea of the sitter's actual appearance. Today, however, images of every celebrity, however temporary, can be transmitted instantly to every quarter of the globe.

Sir Winston Churchill
by Yousuf Karsh,
1941
Photograph

It is not surprising, therefore, that no major painter of talent since Sargent has devoted the majority of his *œuvre* to portraiture. No new Rembrandt,

2

Gainsborough or Goya has established in our minds a vision of the age and society in which we live. No David has succeeded in creating the definitive image of the heroes of our time with a Napoleon on horseback or a Marat, forever slain in his bath. The very multiplicity of images of the famous today has been a hindrance to the painter seeking to create a portrait which is both memorable and profound. The greatest portraits in 20th century art have often been private works of members of the artist's family or of a close circle of friends. Unencumbered by the restrictions of public taste or by the over-exposure of their sitters in the news media, most of the great artists of the 20th century have at some time produced portraits which may be ranked among their best work. Picasso is one of the most notable examples, using the discipline of portraiture to create masterpieces in most of his revolutionary stylistic phases.

Mick Jagger
by Andy Warhol,
1975
Silkscreen print

Our visual memories of the amorphous figure of Gertrude Stein and the bespectacled austerity of Stravinsky are almost certainly based on his portraits of them and belie the general rule about the dominance of the photographic image. The expressionists, Munch, Kokoschka, Beckmann,

Kirchner and latterly Francis Bacon, have produced many of their most profound comments on the human condition in portraits of themselves and of close friends. In the National Portrait Gallery's modern collection, paintings of family and friends include Duncan Grant's two portraits of Vanessa Bell and Michael Ayrton's painting of Sir William Walton (page 25); and there are self-portraits by many leading British artists such as Dame Laura Knight (page 9), Graham Sutherland (page 22), and Dame Barbara Hepworth (page 21).

If portraiture, especially between the wars, seemed to be the preserve of an enfeebled academic conservatism, with a few eccentric flashes of brilliance from avant-garde artists better known for their work in other fields, there are signs that a younger generation of artists has recovered from the long supremacy of abstract art and is prepared to come to terms with the challenge of photography in various ways. Regarding it as a parallel discipline or merely using it as a mechanical means to an end, painters like Warhol and Hockney have turned photography to their own advantage and shown that the subjective eye of the artist can transcend the mechanical eye of the camera. Using a photographic image of one of the most photographed people of our time, Warhol has ironically created perhaps the most

3

enduring icon of post-war years in his portraits of Marilyn Monroe, effectively distilling a lifetime's photographs into one unforgettable image. Ruskin Spear also painted public figures from press photographs, a tradition established by Sickert, and portraits such as his *Harold Wilson* (page 29) demonstrate the particular element of humour which separates him from artists of the avant-garde who use the same process. Painters like Bacon and some of the younger neo-expressionists have used photographs for reference in order to eliminate any disturbance from the physical presence of the subject. Where sittings with a busy public figure are likely to be limited, a successful contemporary portrait painter like Bryan Organ, for instance, relies on sketches and his own photographs for the physical appearance of his subject.

The National Portrait Gallery collection

The difficulty of collecting portraits of eminent contemporaries is one that was initially side-stepped when the Gallery was founded in 1856, and portraits of living sitters were not admitted into the collection. It was soon realized, however, that many important subjects were not entering the collection, either because existing portraits remained with the families or because they were given to other institutions, and a National Photographic Record was set up in 1917. The results of this co-operation between the Gallery and one fairly undistinguished studio photographer are not altogether encouraging and although the lists submitted by the Gallery of predictable establishment figures were widened in 1967, the

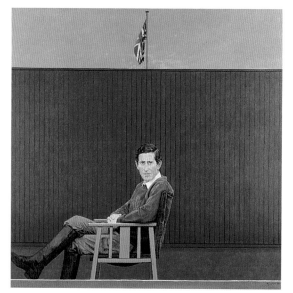

HRH The Prince of Wales
by Bryan Organ,
1980
Acrylic on canvas

Record was finally abandoned in 1972 in favour of a less regimented approach. The Gallery's policy of holding regular photographic exhibitions has played a large part in building up the photographic collection and regular purchases are made both from photographers and the sale rooms.

The possibility of commissioning paintings or sculpture was, with the exception of a very few royal portraits, barely contemplated until quite recently. The Trustees' rule barring the acquisition of portraits of living sitters was finally altered in 1969, and in 1980 a sum

4

of money from the annual purchase grant was set aside to commission a limited number of portraits of eminent sitters. The first included Bryan Organ's portraits of The Prince and Princess of Wales and Suzi Malin's *Lord Home*, while other commissions began to enter the collection as a result of the annual Portrait Award, sponsored by Imperial Tobacco (continued by John Player and now sponsored by BP) for artists under the age of 40. Instituted in 1980, part of the first prize is a commission for the Gallery. The fact that in 1982, the commission was for a portrait of

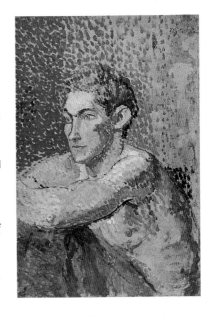

George Mallory
by Duncan Grant,
1912
Oil on panel

the pop singer, composer and former Beatle, Paul McCartney, shows how far the Gallery's attitude had broadened since the days when the Photographic Record took photographs of generals and top civil servants as a matter of course. Outstanding Portrait Award commissions since then include Rosemary Beaton's *Sir Robin Day* (page 38), a choice which recognizes the importance of the media in contemporary life, and Alison Watt's *HM The Queen Mother* which caused a storm of controversy at the time of its unveiling in 1989 but is increasingly accepted as an important work. A policy of regular commissions has also enabled the Gallery to approach a number of established contemporary artists such as Allen Jones, Tom Phillips and Eduardo Paolozzi, whose work, in the normal course of events, might never have entered the collection. Paolozzi's commissioned bronze of the architect Richard Rogers (1988) is dissected and re-organized in a cubist manner which challenges our notion of a conventional likeness in much the same way as two other celebrated commissions: John Bellany's stylized and expressionist portrait of Ian Botham (page 36) and Maggi Hambling's painting of the scientist Dorothy Hodgkin (page 26) with its multiple hands.

The Twentieth Century Galleries

The Early Twentieth Century Galleries on Level 2 cover the period from 1914 to 1945. Gallery 26 is dominated by the two huge group portraits from the First World War: the Generals by John Singer Sargent and the

5

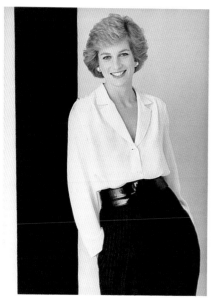

Statesmen by Sir James Guthrie. Other significant historical works are Sickert's portrait of Lord Beaverbrook, Henry Lamb's *Neville Chamberlain*, Frank Salisbury's *Field Marshal Montgomery* (page 17) and Augustus John's celebrated drawing of T.E. Lawrence (page 11). There are also important groups of work by Sir William Orpen and Sir John Lavery and a collection of portraits of artists and writers of the Vorticist group including self-portraits by Epstein and Gaudier-Brzeska. Outstanding photographs in this gallery include works by Cecil Beaton, Baron De Meyer (page 8), and Yousuf Karsh.

Gallery 27 houses a miscellany of between-the-wars scientists, academics, businessmen, actors, film stars and sportsmen. Of particular significance here are Sir James Gunn's portrait of the atomic theorist Sir Ernest Rutherford, Powys Evans's sparkling art deco cartoon of Gordon Selfridge, Epstein's bust of Dame Sybil Thorndike and Duncan Grant's avant-garde painting of the mountaineer George Mallory. The small Gallery 28 is devoted to the Arts and contains many of the Gallery's modern treasures. A substantial collection of portraits of the Bloomsbury Group includes Duncan Grant's portrait of Vanessa Bell (page 13), Bell's portrait of her sister, Virginia Woolf (page 15), self-portraits by Sir Stanley Spencer, Mark Gertler, Henry Lamb, Sir Cedric Morris and William Roberts, and Roberts' celebrated double portrait of the economic theorist Maynard Keynes and his wife, the ballet dancer Lydia Lopokova. Here also are two memorable paintings by Augustus John of his son, Admiral Sir Caspar John, and of Lady Ottoline Morrell (page 12), and Christopher Wood's Modiglianiesque portrait of the composer Constant Lambert and one of Tchelitchew's portraits of Dame Edith Sitwell.

HRH The Princess of Wales by David Bailey, 1988 Photograph

The Later Twentieth Century Galleries on Level 1, which opened in 1993, provide a spacious new environment for the modern collection and include the Porter Gallery (30) for newly acquired and commissioned works, and the Emmanuel Kaye Gallery (32) for science, technology and business portraits. A Photography Gallery (35) plays host to changing displays, some drawn from the Gallery's own substantial photographic collection and others of small loan exhibitions of the work of contemporary photographers. The permanent galleries themselves will also change their displays at regular intervals but are arranged around the long

corridor (Gallery 31) which contains the portraits of politicians and establishment figures from Bryan Organ's *Harold Macmillan* (page 23) to Tom Wood's portrait of HRH The Prince of Wales (page 34). The display includes a large number of photographs by distinguished names from Cartier-Bresson, Eve Arnold and Bill Brandt (page 30) to more recent figures such as David Bailey and Steve Pyke. Notable literary portraits include Tom Phillips' *Iris Murdoch* series, several paintings by Peter Edwards including *The Liverpool Poets* and Patrick Heron's late cubist portrait of T.S. Eliot (page 19). Many famous post-war British artists are represented including Lucian Freud, Graham Sutherland (page 22), David Hockney (page 32), John Bratby and Ben Nicholson in a memorable small self-portrait of 1933 with his then wife, Barbara Hepworth (page 20). Small groups of works devoted to outstanding figures from the worlds of pop music and sport emphasize the increasing preoccupations of post-war leisure and include Sam Walsh's portrait of Paul McCartney (page 33), Peter Edwards' grandiose portrait of Bobby Charlton, Suzi Malin's witty homage to Elton John and Ray Richardson's recent painting of the boxer Lennox Lewis. The ever-widening collection of sculpture encompasses spectacular multi-media portraits by Andrew Logan of the ballerina Lynn Seymour and fashion-designer Zandra Rhodes, a number of distinguished bronzes by Eduardo Paolozzi and Elisabeth Frink and a monumental new stone carving by Glynn Williams of the academic and administrator Lord Annan. The collection itself remains, as ever, an engaging mixture of the masterpiece and the modest, the artistic and the archival – one of the many idiosyncracies that make the National Portrait Gallery such a unique institution in the world of galleries and museums today.

Dame Iris Murdoch
by Tom Phillips,
1984-6
Oil on canvas

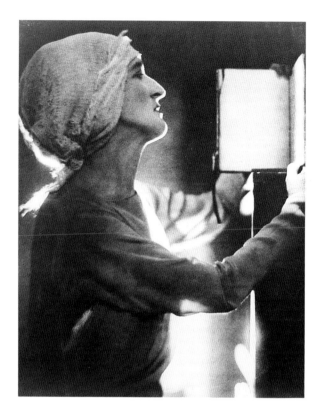

By Baron Adolf de Meyer, 1911
Silver print,
43.5 x 35.2 cms
Level 2

Emma Alice Margaret ('Margot') Tennant, Countess of Oxford and Asquith
1864-1945

'Unteachable and splendid', Margot Asquith was a leader of taste and fashion for most of her long and colourful life. Her volumes of autobiography and memoirs, her novel and essays, are largely forgotten, but stories of her *bons mots* are legion. A puritan at heart and a moralist in practice and in print, she was catholic in her acquaintances and knew most of the leading thinkers and politicians of her day. In 1894 she married, as his second wife, Herbert Asquith, Liberal politician and (from 1908-16) Prime Minister.

A man of deliberately mysterious origins, de Meyer was brought up in Paris but lived in England until, suspected of German sympathies, he left for New York with his wife Olga at the outbreak of the First World War. In America he was employed by Condé Nast and his elegant, aesthetic photographs, which had been all the rage in Europe, began to appear in the pages of *Vogue* and *Vanity Fair*.

8

Self-portrait, 1913
Oil on canvas,
152.4 x 127.6 cms
Level 2

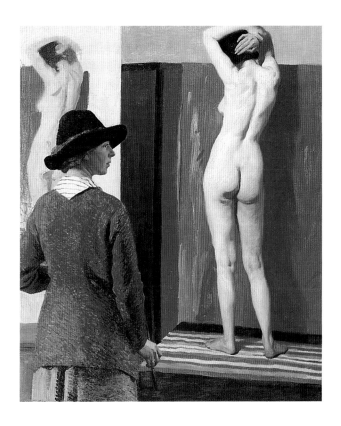

Dame Laura Knight

1877-1970

Laura Knight's long and productive career began at art school in Nottingham where she met her future husband Harold Knight. After ten years as part of the artists' colony at Newlyn in Cornwall, they settled in London in 1919 and it was during the inter-war years that Laura Knight painted the ballet, theatre, circus and gypsy scenes for which she is best known. In 1946 she was sent by the War Artists' Advisory Committee to record the Nuremberg War Trials.

During 1912 and 1913, as she wrote in the autobiographical *Oil Paint and Grease Paint* (1936), she 'became definitely aware of an ability that enables eye and hand to work simultaneously without conscious intervention of thought'. Depicting herself here in a cardigan known as 'The Cornish Scarlet' (it had been bought at a jumble sale for half a crown), the artist has achieved a painting of complex structure which still retains a feeling of intuitive harmony. The nude model was Laura Knight's neighbour and friend Ella Naper, also a painter.

9

Field Marshal Lord Allenby

1861-1936

Allenby had fought for three years on the Western Front before taking command of the Egyptian Expeditionary Force in June 1917, directing the Allied offensive against the Turks. His thoroughness, sincerity and clear-thinking were responsible for a series of successful campaigns that liberated Jerusalem and Damascus and led to an armistice with the Turks at the end of 1917. They were also qualities that recommended him to the most famous officer under his command, T.E. Lawrence, to whom he gave his support.

The drawing of Allenby was one of many commissioned by Lawrence from Eric Kennington, art editor of the subscribers' edition of *Seven Pillars of Wisdom* (1926). At an exhibition of the illustrations it was bought for Lawrence by his friend Edward Garnett and hung, with Augustus John's painting of the Emir Feisal, in Lawrence's cottage. After Lawrence's death the drawing was given to the National Portrait Gallery by his brother.

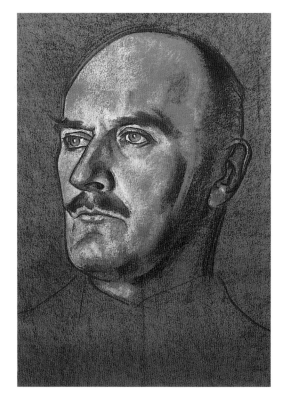

By Eric Kennington, 1921
Pastel on paper,
44.5 x 33.7 cms
Level 2

Thomas Edward Lawrence

1888-1935

The drawing of Lawrence of Arabia is one of the Gallery's most famous images, conveying in its few lines the magnetism of the most romantic hero to emerge from the First World War. It was drawn, according to Lawrence, 'in two minutes' at the Versailles Peace Conference and was given by him to Charlotte and George Bernard Shaw who in turn presented it to the National Portrait Gallery in 1944.

As liaison officer to the Emir Feisal of the Hejaz, Lawrence helped to sustain the revolt of the Arabs against Turkish rule, inspiring and performing extraordinary feats of courage and endurance, but it was not until after the war that the publicity generated by the American journalist, Lowell Thomas, made him a household name. Fame, however, did not rest easily on his shoulders and though he wrote a celebrated account of the war in the desert, *Seven Pillars of Wisdom*, the latter part of his life was spent in (well publicized) obscurity in the ranks of the RAF under an assumed name. Three months after leaving the RAF, at the age of only 46, he was killed in a motorcycle accident near his cottage in Dorset.

By Augustus John, 1919
Pencil on paper,
35.6 x 25.4 cms
Level 2

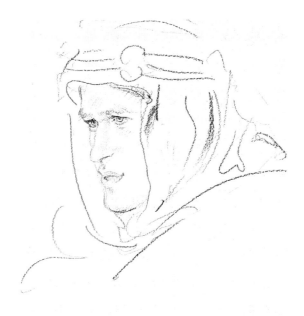

11

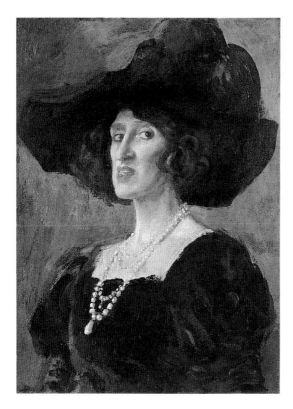

By Augustus John, c.1919
Oil on canvas,
69 x 51.1 cms
Level 2

Lady Ottoline Morrell

1873-1938

Half-sister to a Duke, daughter of a general and wife of a pacifist MP, Lady Ottoline was as grand as she was unconventional. During the first quarter of the century her home, at first in London and from 1913 to 1924 at Garsington Manor in Oxfordshire, was a refuge and a source of encouragement, patronage and inspiration for a glittering string of contemporary artists and intellectuals. 'The Garsington Set' at various times included D.H. Lawrence, Bertrand Russell, Henry Lamb, Lytton Strachey, Aldous Huxley, W.B. Yeats and, from 1908, Augustus John. A brief affair between John and Lady Ottoline was over by 1909, but the portrait, made about ten years later, is a testament to their lasting friendship. Thought to be unflattering, this masterpiece by one of the foremost British portrait painters of the century was highly controversial when first exhibited. It hung over the dining-room mantelpiece at the house in Gower Street where the Morrells moved on leaving Garsington in 1924 and was acquired by the National Portrait Gallery from the estate of Lady Ottoline's daughter in 1991.

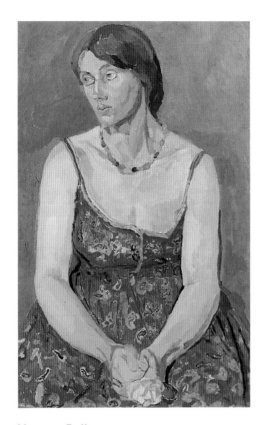

By Duncan Grant, c.1918
Oil on canvas,
94 x 60.6 cms
Level 2

Vanessa Bell
1879-1961

Like her sister Virginia Woolf, Vanessa Bell was an innovator in her field. Taught at
the Royal Academy Schools by Sargent and influenced by Whistler and the New
English Art Club, she was inspired by the Post-Impressionist exhibitions
organized by Roger Fry in 1910 and 1912, and her sober, tonal painting underwent a
radical change. Simple design, bold use of colour and experiments with abstraction
characterized a transitional period before she settled into a personal form of repre-
sentation that had much in common with the work of Duncan Grant. In 1907
Vanessa married the art critic Clive Bell, but lived with Duncan Grant from 1913 and
together they worked for the Omega Workshops as well as collaborating on various
decorative schemes, most notably in their own home, Charleston. The painting is
one of two magnificent portraits of Vanessa Bell by Duncan Grant in the collection
of the National Portrait Gallery.

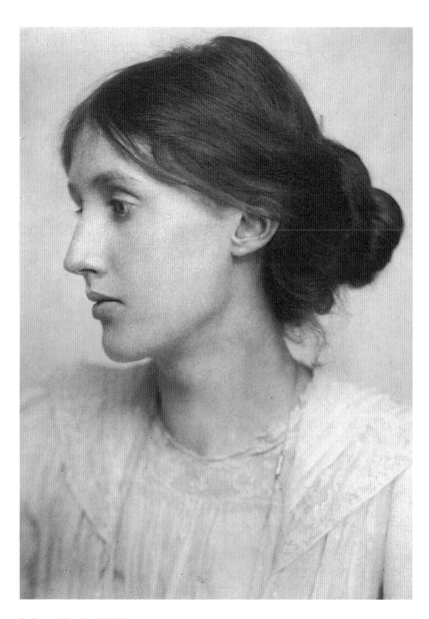

By George Beresford, 1902
Platinum print,
15.2 x 10.8 cms
Level 2

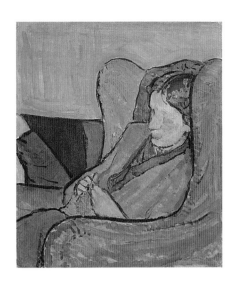

Virginia Woolf

1882-1941

An innovative and pioneering novelist Virginia Woolf was, like James Joyce, an exponent of the 'stream of consciousness', transforming in such works as *Mrs Dalloway* (1925), *The Waves* (1931) and *The Years* (1937), the narrative structure of traditional fiction. Virginia and her siblings, Vanessa, Adrian and Thoby, the children of Sir Leslie Stephen, were at the heart of the Bloomsbury Group, a loose association of Thoby's Cambridge friends that included Roger Fry, Maynard Keynes, Lytton Strachey, E.M. Forster, Clive Bell and Leonard Woolf.

Beresford's ethereal platinum print dates from the beginning of Virginia Woolf's literary career and is justly regarded among the Gallery's most celebrated images. Though reluctant to sit for her portrait (she refused to do so for the National Portrait Gallery), Virginia was the subject of four paintings by her sister in 1912, the year of her marriage to Leonard Woolf.

By Vanessa Bell, 1912
Oil on canvas, 40 x 34 cms
Purchased with help from the
National Art Collections Fund, 1987
Level 2

15

By Frank O. Salisbury, 1945
Oil on canvas, 102.2 x 126.7 cms
Lent by the sitter's son,
Viscount Montgomery, 1977
Level 2

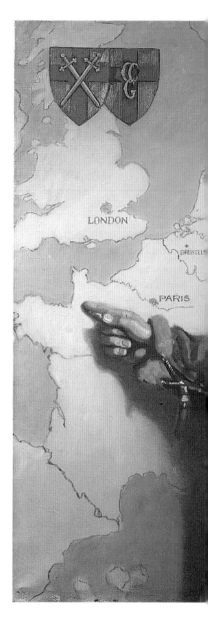

Bernard Law Montgomery,
1st Viscount Montgomery of Alamein

1887-1976

Before Alamein we never had a victory, pronounced Churchill; after it we never suffered a defeat. The victory of the 8th Army at Alamein in 1942 was pre-eminently Montgomery's victory and assured his reputation as Britain's finest field commander since Wellington. An exacting disciplinarian and a meticulous planner, his genius lay in his extraordinary ability to inspire enthusiasm and loyalty in his troops. Admired by Churchill, he was entrusted with the command of the 21st Army Group in the invasion of Europe, and is seen here in a Canadian flying jacket pointing to the Normandy beaches. The insignia in the upper left hand corner are those of the 21st Army Group and its successor, the Control Commission in Germany.

Montgomery commissioned the portrait himself and flew the 71 year old London artist to his Headquarters in Berlin for a sitting. Salisbury, veteran painter of royalty and presidents, had never flown before and described the episode in his autobiography *Sarum Chase* (1953) with all the enthusiasm of a schoolboy, delighted particularly that Montgomery had signed and given him the campaign map featured in the background of the portrait.

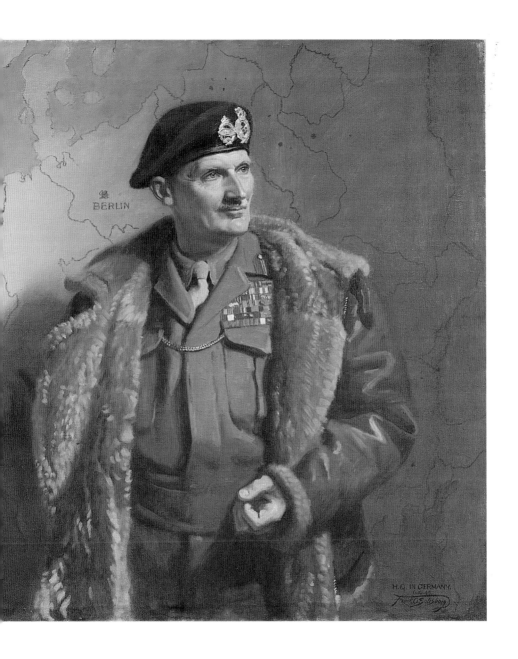

BERLIN

H.Q. IN GERMANY.
1945

Thomas Stearns Eliot

1888-1965

Although Eliot's eclecticism has laid him open to charges of obscurity, he remains arguably the greatest modern poet of the English language. The anti-romanticism and intellectual toughness of *The Wasteland* (1922) deposed the poetry of Eliot's Georgian contemporaries and became the dominant literary influence on young writers of the time. Eliot's later poems such as *Ash Wednesday* (1930) and *The Four Quartets* (1944) and his verse play *Murder in the Cathedral* (1935) reflect the Christian belief that played an increasingly important role in his life and work.

By Sir Jacob Epstein, 1951
Plaster, 48.3 cms high
Given by the Trustees of
the Epstein Estate, 1965
Level 2

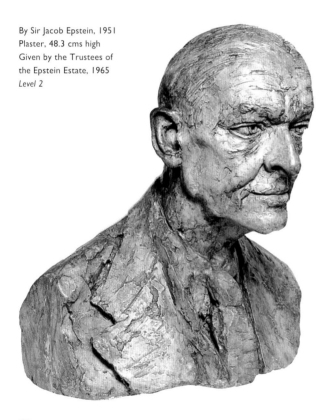

The portrait by Epstein was commissioned by the playwright Ashley Dukes, a friend of both the sculptor and Eliot. The portrait was cast in bronze in an edition of six, four of which are now in collections in the United States. The study by Patrick Heron is the definitive version of three portraits of Eliot by the artist and close in style to Heron's painting of Herbert Read, also in the Gallery's collection.

By Patrick Heron, 1949
Oil on canvas, 76.2 x 62.9 cms
Purchased with help from the
Contemporary Art Society, 1965
Level 1

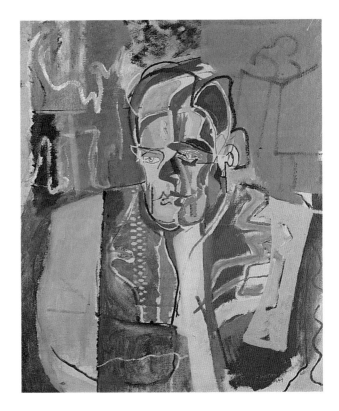

St Rémy Provence
By Ben Nicholson, 1933
Oil on canvas,
27.3 x 16.8 cms
Level 1

Dame Barbara Hepworth

1903-1975

It is with St Ives in Cornwall, where she moved at the beginning of the Second World War, that the sculptor Barbara Hepworth will always be associated. There she and her second husband, Ben Nicholson, pioneers of the abstract movement in British art, were at the heart of a group of artists collectively inspired by the Cornish landscape. Like her close colleague and contemporary, Henry Moore, Hepworth made extensive use of the 'hole' in abstract sculpture, often developing the interior space it created through subtle use of colour and strings.

Hepworth's self-portrait, unique in her *œuvre*, was given by the sculptor to her friend the composer Priaulx Rainier who in turn bequeathed it to the National Portrait Gallery. The portrait reveals the artist in front of her raw material at the point of creative inspiration, 'the moment of vision before the first blow of the chisel' as Dr Rainier described it in a letter to the Gallery. Nicholson's semi-abstract self-portrait with Barbara Hepworth, entitled *St Rémy Provence*, is also unusual in his work, marking a brief period when he concentrated on the human profile.

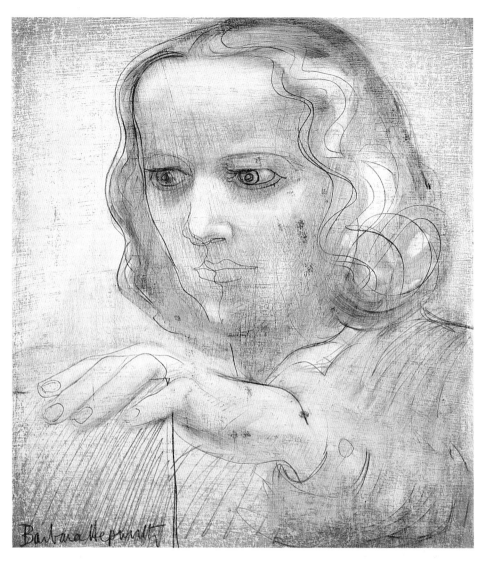

Self-portrait, 1950
Oil and pencil on board,
30.5 x 26.7 cms
Level 1

Graham Sutherland

1903-1980

Up until the 1950s, Graham Sutherland's work was concerned with still life, landscape and anthropomorphized natural forms; his vast tapestry, commissioned in 1952 for the new Coventry Cathedral, is probably the most widely known image from this time. It was in 1948 that a chance remark resulted in his portrait of Somerset Maugham and its success led in turn to a series of paintings that rank Sutherland as Britain's most important portrait artist of the middle years of this century. The self-portrait (a rare subject for Sutherland) was painted expressly for the National Portrait Gallery's Sutherland exhibition in 1977 and was given to the Gallery by the artist's widow in 1980.

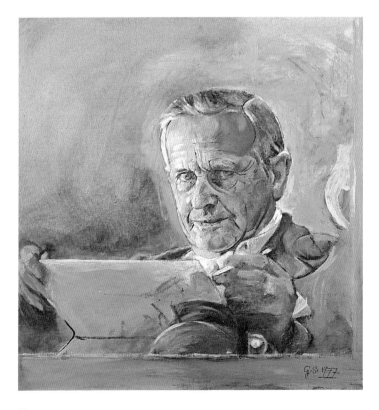

Self-portrait, 1977
Oil on canvas,
52.7 x 50.2 cms
Level 1

Harold Macmillan, 1st Earl of Stockton

1894-1986

After a succession of senior cabinet posts under Churchill and Eden, Macmillan succeeded to the Conservative leadership in 1957, the first intellectual, it was said, to lead the party since Balfour. As Prime Minister (1957-63), Macmillan presided over the crucial years of post-War recovery, exercizing formidable powers of statesmanship in the international arena and laying the foundation for Britain's entry into Europe. It is probably with the retreat from empire that Macmillan's name is most closely linked, signalled by his speech in 1960 to both Houses of the South African Parliament in which he declared: 'A wind of change is blowing through the continent.'

From 1960 Macmillan was Chancellor of the University of Oxford. This portrait, commissioned by the Trustees of the National Portrait Gallery, relates closely to Bryan Organ's diptych of Macmillan painted at the same time for the University.

By Bryan Organ, 1980
Acrylic on canvas,
91.4 x 91.4 cms
Level 1

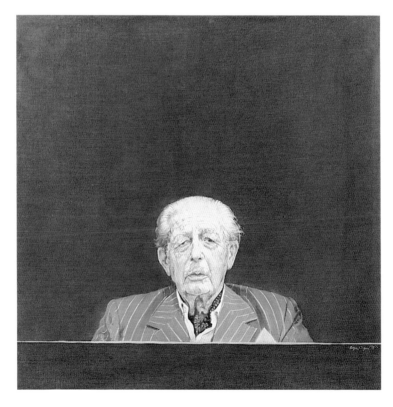

Sir William Walton

1902-1983

Walton's precocious musical genius was recognized
by a succession of benefactors and well-wishers.
A chorister and undergraduate at Christ Church, on
leaving Oxford he was taken up by Sacheverell and
Osbert Sitwell. The association broadened his cultural
and social horizons and led to his collaboration with
Edith Sitwell on *Façade* (1922). Owing various debts to
popular music and jazz, to Elgar and romanticism,
Prokofiev and Stravinsky, Walton's individual style
ranged from the deep seriousness of his *Viola Concerto*
(1928-9) and *First Symphony* (1932-5) to ceremonial
music for the coronations of both King George VI and
Queen Elizabeth II and the scores for 14 films.

By Maurice Lambert, *c.*1925
Bronze, 27 cms high
Level 1

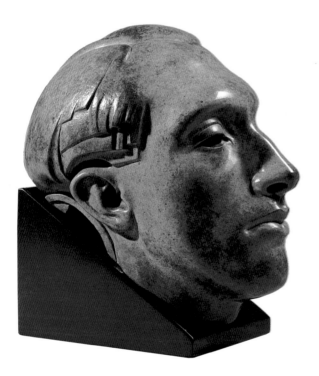

24

The two representations of Walton, separated by a period of more than twenty years, reflect general trends in the art and music of the time. The modernist head by Lambert, brother of the composer Constant Lambert, echoes, in its pure line, the svelt style of the 1920s, the time of *Façade*. By contrast Ayrton's painting is in the neo-Romantic style, a return to elegy and lyricism that also characterizes Walton's mature compositions. The portrait is set in Capri where Ayrton accompanied the composer during his convalescence from jaundice. The following year Walton settled permanently on the neighbouring island of Ischia.

By Michael Ayrton, 1948
Oil on canvas, 61.3 x 91.5 cms
Level 1

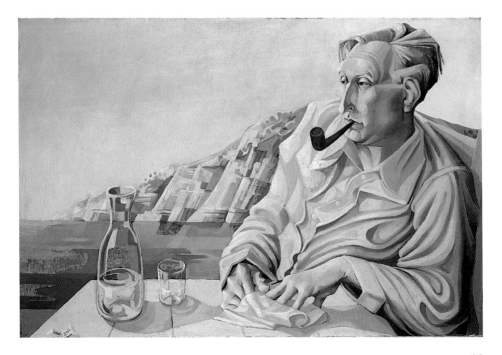

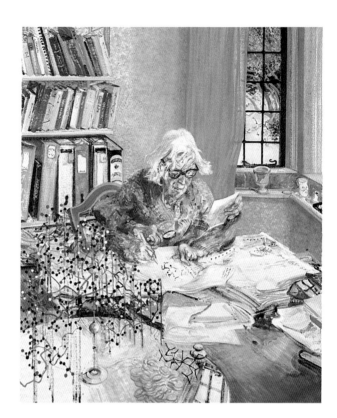

By Maggi Hambling, 1985
Oil on canvas,
93.2 x 76 cms
Level 1

Dorothy Hodgkin

born 1910

In 1933 the chemist and crystallographer Dorothy Hodgkin became the first scientist to make an X-ray diffraction photograph of a protein. She subsequently used this technique to define the structure of penicillin (with Charles Bunn, 1942-9), insulin (1969) and most importantly Vitamin B_{12}, one of the most complicated non-protein molecules found in nature. She was made a Fellow of the Royal Society in 1947 and was awarded the Nobel Prize in 1964 for her work on Vitamin B_{12}. The following year she was made a member of the Order of Merit, its second woman member after Florence Nightingale.

Commissioned by the Gallery's Trustees, Maggi Hambling's portrait vividly expresses the scientist's life. Surrounded by the attributes of her research – files, books, structural models and computer print-outs – a vigorous energy is indicated by her four arthritic but tireless hands.

26

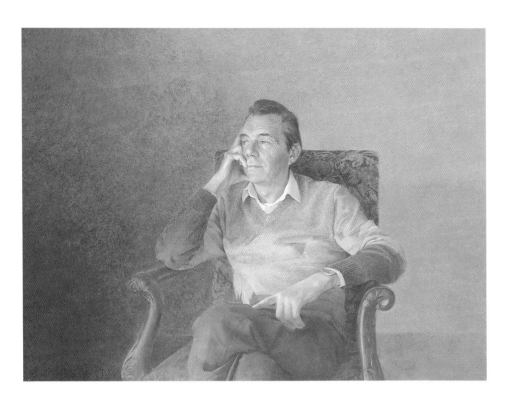

By David Tindle, 1986
Egg tempera,
64.8 x 84.1 cms
Level 1

Sir Dirk Bogarde

born 1921

Doctor at Sea (1955) and *Death in Venice* (1971) mark the artistic parameters of Bogarde's career as a film actor. Typecast originally as a matinée idol, he first escaped to more demanding work with his 1961 portrayal of a homosexual barrister in *Victim*. At a stroke Bogarde had alienated his erstwhile fans but from this time on a penetrating and often disturbing psychological insight characterizes such roles as Hugo Barrett in Joseph Losey's *The Servant* (1963), Aschenbach in Visconti's *Death in Venice* and Max in *The Night Porter* (1974). A second career as a writer has produced six volumes of autobiography and four novels.

The portrait was commissioned by the Gallery's Trustees from David Tindle, a Royal Academician whose pointillist technique is better known in his exquisite still lifes and interiors than in portraiture.

27

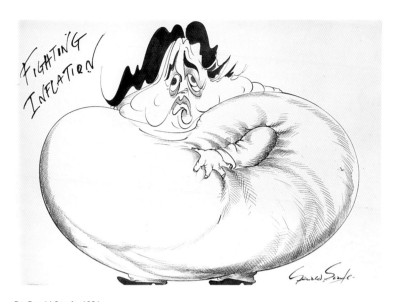

By Gerald Scarfe, 1986
Pen and indian ink on paper,
59.4 x 83.8 cms
Level 1

Nigel Lawson, Baron Lawson of Blaby

born 1932

A Conservative MP for Blaby in Leicestershire from 1974, Nigel Lawson succeeded Geoffrey Howe as Chancellor of the Exchequer in 1983 and became the main architect of the Thatcher administration's monetarist policies. *Fighting Inflation* appeared in the *Sunday Times* on 18 October 1986, three days after the Chancellor's Mansion House speech had failed to allay fears of rising inflation. Lawson resigned from the Treasury in 1989 and was made a life peer in 1992.

Gerald Scarfe became known in the 1960s as one of Britain's most savage caricaturists. His work has appeared in *Punch*, *Private Eye*, the *Daily Mail* and *Time Magazine* as well as the *Sunday Times*. In recent years he has also made various films for the BBC and in 1985 designed the sets for *Orpheus in the Underworld* at the English National Opera. His caricatures of Margaret Thatcher and of Denis Healey are also in the National Portrait Gallery collection.

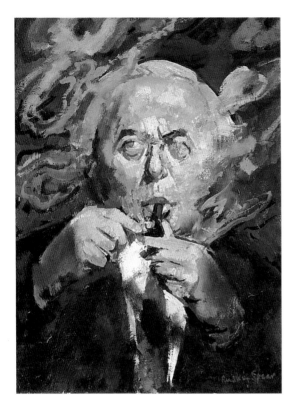

By Ruskin Spear, 1974
Oil on canvas,
51.1 x 38.1 cms
Level 1

Harold Wilson,
Baron Wilson of Rievaulx

born 1916

Labour had been out of office for 13 years when Wilson led the Party
to victory in the general election of 1964. In opposition he had remarked
that he was 'running a Bolshevik Revolution with a Tsarist Shadow
Cabinet' but Labour's fragile overall majority (four) unified opposing wings
of the Party and it was largely due to Wilson that the 1966 election was
comfortably won. A second term (1974-6) ended in his resignation at the
surprisingly early age of 60. Like Churchill's cigar, Wilson's pipe is his
personal trademark and in Spear's portrait it becomes a visual *jeu d'esprit*
which the artist exploits to the full. The title of the painting is simply
Man with a Pipe.

Amiable paintings of London characters, cosy urban scenes and raffish
cats characterize much of Spear's work together with a series of portraits
which, in the tradition of Sickert, make liberal use of snapshots and
newspaper photographs.

Peter Sellers

1925-1980

Complete with bump (or 'bermp' as he would call it) on his head, Peter Sellers is seen here in the character of Inspector Clouseau on the set of *A Shot in the Dark*, the second of four 'Pink Panther' films featuring the inept French policeman. Sellers had a certain following as a member of the anarchic *Goon Show* on radio (1951-60) and his comic genius became more widely recognized with films such as *The Ladykillers* (1955) and *I'm All Right Jack* (1959), but it was Clouseau that made him an international celebrity. The tragi-comic hero who inadvertently causes mayhem is a theme often portrayed by Sellers and reappears in one of his last films, *Being There* (1979), when he plays a gardener whose simple horticultural lore becomes, through a series of accidents, the higher political wisdom of the United States.

The photograph, with a number of others, was given to the National Portrait Gallery by the renowned photographer, Bill Brandt, in 1982.

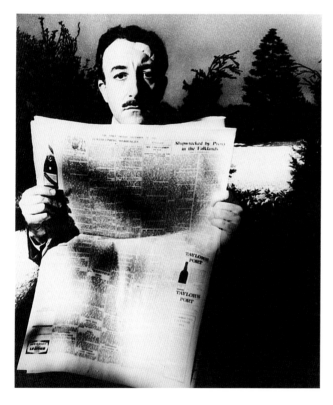

By Bill Brandt,
1963
Bromide print,
34.2 x 28.9 cms
Level 1

Elizabeth Taylor

born 1932

Though born in London, Liz Taylor's parents were American and the family was evacuated to Beverly Hills in 1942. It was there that her fortunes lay and a succession of films as a child star reached its climax with *National Velvet* (1944), where her portrayal of Velvet Brown's obsession gave a hint of the best performances of her adult career. Embittered, frustrated or angry characters have brought out her most powerful acting in roles such as Maggie Pollitt in *Cat on a Hot Tin Roof* (1958) and Martha in *Who's Afraid of Virginia Woolf?* (1966).

Andy Warhol was probably the most widely known exponent of American Pop Art and in his multiple images of Campbell's Soup cans and Coca Cola bottles created an art form whose impious creed exalted commercial production at the expense of the individual artist's craftsmanship. Like his better known portraits of Marilyn Monroe, the lithograph of Liz Taylor derives from a photograph and is similar in style to the portraits of Her Majesty The Queen and Mick Jagger, also on view in the Late 20th Century Galleries.

By Andy Warhol,
1967
Offset lithograph,
55.6 x 55.6 cms
Level 1

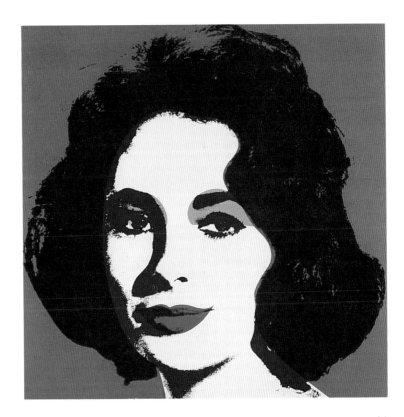

31

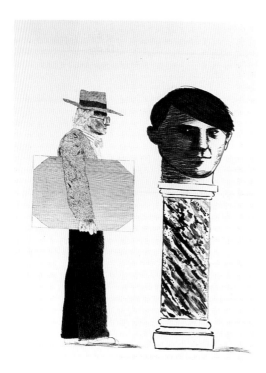

The Student – Homage to Picasso
Self-portrait by David Hockney,
1973
Etching, 57.2 x 43.5 cms
Level 1

David Hockney

born 1937

One of a handful of 20th Century British artists to achieve an international reputation, Hockney's work owes greater allegiance to his adopted California than to his Bradford background. Best known for the flat acrylic paintings of swimming pools and such portraits as *Mr and Mrs Clark and Percy* (1970-1, Tate Gallery), Hockney's work embraces superb line drawings and etchings, theatre design, photographic collage, bright Californian landscapes and, most recently, Fax art. The etching's title acknowledges Hockney's debt to his greatest mentor.

Hockney's only commissioned portrait, of the Royal Opera House administrator Sir David Webster, also hangs in the Late 20th Century Galleries.

By Sam Walsh, 1964
Oil on hardboard,
160 x 153 cms
Level I

Paul McCartney

born 1942

The portrait is ironically entitled *Mike's Brother* since it was Mike McCartney, a photographer, who was a friend of the artist Sam Walsh and not his world-famous brother, the Beatle. In 1964 when the portrait was painted, Beatlemania was at its height: it was the year of the album and film *A Hard Day's Night*, the album *Beatles for Sale*, the MBEs, the coast-to-coast USA tour and three UK number one hits including *Can't Buy Me Love*, the first record to top the UK and USA charts simultaneously. The phenomenon had another six years to run before the Beatles disbanded in 1970.

Sam Walsh was born in Ireland and went to Liverpool 'for the weekend' in 1960, but stayed for the rest of his life. He became a member of the Liverpool Academy in 1966 and taught at Liverpool College of Art from 1968. A contemporary of the pioneers of British Pop, Walsh retained closer stylistic links throughout his career with his American contemporaries. According to his friend, the poet Adrian Henri, 'the liberating influence came from … Johns, Rauschenberg, Dine and Rivers', and his series of large heads and interest in photo-realism and spray-paintings link him with a later generation of American and European painters, including Chuck Close, Gerhard Richter and Franz Gertsch.

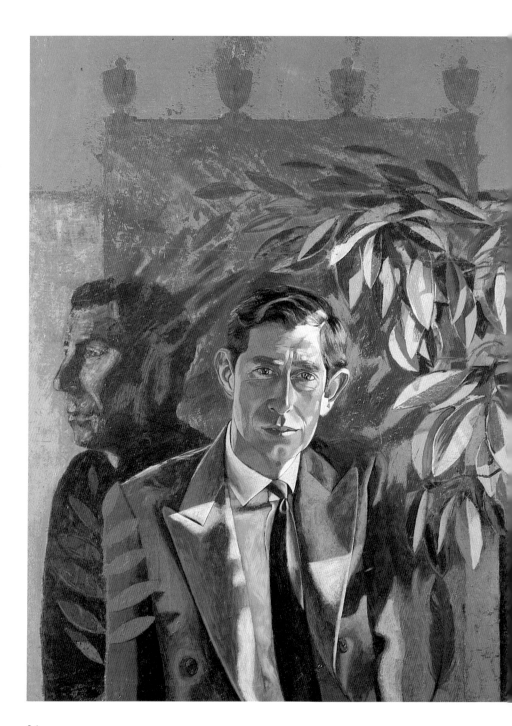

HRH The Prince of Wales

born 1948

The Prince of Wales's patronage of young artists has
led to a number of commissioned portraits of himself.
When opening the Dean Clough Industrial Park in
Halifax in 1987, the Prince visited an exhibition of
recent work by Tom Wood and subsequently invited
the artist to paint him. Three portraits resulted: a
small oil study of the Prince's head and a half-length
study, both of which belong to the Prince, and this
larger panel painted by the artist for himself. Although
Wood's highly personal symbolism eludes specific
meaning, various aspects of the painting can be
identified with the Prince's known interests: architec-
ture (in particular Highgrove, the Prince's home in
Gloucestershire, indicated by the building in the
background), horticulture and garden design.
The shadowy figures to the left and right are unex-
plained but may be seen as alter egos or as the ever-
present security personnel, the price of public life.

One of the leading portrait painters of the younger
generation, Tom Wood's recent work has included
a portrait of the playwright and actor Alan Bennett,
commissioned by the Trustees of the National Portrait
Gallery in 1993, and also hanging in the Late 20th
Century Galleries.

By Tom Wood, 1989
Oil on panel, 152.4 x 157.5 cms
Lent from a Private Collection
Level 1

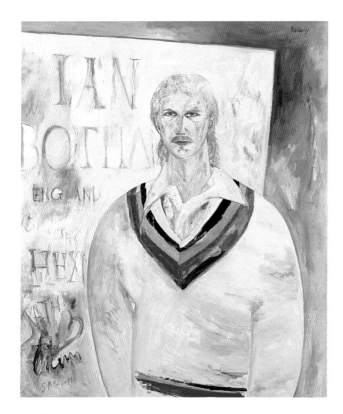

By John Bellany, 1985
Oil on canvas,
171.9 x 152.4 cms
Level 1

Ian Botham

born 1955

England's greatest and most controversial all-rounder this century, Botham made his test début against the Australians in 1977 and on his first day took five wickets for 74. The records accumulated relentlessly throughout his test and county career: the first player to score a century and take eight wickets in an innings against Pakistan in 1978; 1000 runs and 100 wickets in the fewest test matches; the most sixes in a first class season (1985). Most memorable was the Ashes series against Australia in 1981, in which Botham scored centuries at Headingley and Old Trafford and took five wickets for one run at Edgbaston, securing England's victory.

The portrait, commissioned by the Gallery's Trustees, has attracted heated debate since its unveiling in 1985. As with the commissions he has undertaken of other popular heroes (such as Sean Connery painted for the Scottish National Portrait Gallery), John Bellany has produced a subjective image in his own style, making no concessions to the expectations of the sitter's natural audience.

By William Bowyer, 1986
Oil on board,
81.3 x 70.2 cms
Level 1

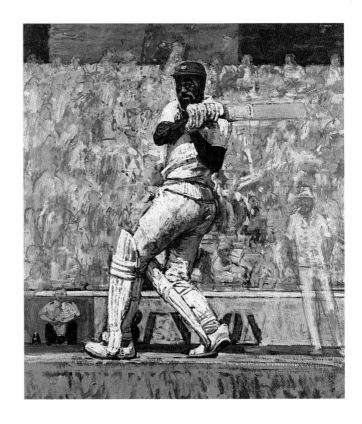

Viv Richards

born 1952

Born in Antigua, Viv Richards made his test début for the West Indies in 1974 and joined forces the same year with his close friend Ian Botham to play for Somerset. Regarded from the start as a world class player, Richards stayed with Somerset for 12 years and was a key element in their popularity. When released by the county side in acrimonious circumstances in 1986, Botham too left in protest. At the height of his career Richards was regarded as the most awesomely destructive batsman in the world, with possibly his most impressive innings being the 291 he scored against England at the Oval in 1976. West Indies' greatest ever run-maker, he was the inevitable successor as captain to Clive Lloyd, and under his leadership between 1985 and 1992 the West Indies never lost a series.

The portrait is unusual in the Gallery's collection in that the subject is seen in action, but is one of many similar studies of cricketers by William Bowyer, himself a keen player and follower of the sport.

Sir Robin Day

born 1923

After studying at Oxford, where he was President of the Oxford Union in 1950, and training for the Bar, Sir Robin Day followed a career in journalism, first as a freelance reporter and later with ITN and the BBC. A bid in 1959 to join the ranks of the Liberal Party as an MP was unsuccessful, but it was as a political commentator that Sir Robin rapidly rose to the top of his profession. His influence was evident in numerous current affairs programmes, such as *Midweek* and *Panorama* on television and *The World at One* on radio, and the authoritative manner and tough interviewing style particularly associated with *Question Time* became a model which many of his successors have followed.

Rosemary Beaton won the Gallery's Portrait Award in 1984, at the age of 21, and this portrait was commissioned by the Trustees as part of the prize.

By Rosemary
Beaton, 1985
Oil on canvas,
152.6 x 122.5 cms
Level 1

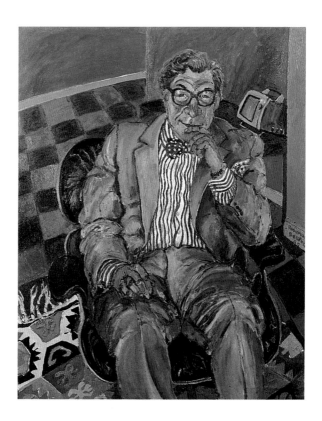

Index

Published by National Portrait Gallery Publications
National Portrait Gallery
2 St Martin's Place
London WC2H OHE

Copyright © National Portrait Gallery, 1993.

ISBN 1 85514 099 3

Written by Robin Gibson and Honor Clerk
Co-ordinated by Joanna Skipwith
Designed by Atelier
Printed in England by BAS Printers